MW00327938

A Venetian Concert

GRAND ITALIAN ARCHITECTURE AND RENAISSANCE MUSIC

Copyright © 2005 by edel CLASSICS GmbH, Hamburg/Germany
Photographic copyright information and credits as listed in the photo index
Music copyright see music credits

ISBN 3-937406-56-5

Editorial Direction: Astrid Fischer/edel, Lori Muenz/edel
Photo Editorial by Bildarchiv Monheim, Meerbusch/Germany
Music compiled by Bernd Kussin/edel
Design by Leslie Strohmeyer
Adapted for earBOOKS mini by Petra Horn

Produced by optimal media production GmbH, Röbel/Germany
Printed and manufactured in Germany

earBOOKS is a division of edel CLASSICS GmbH
For more information about earBOOKS please visit **www.earbooks.net**

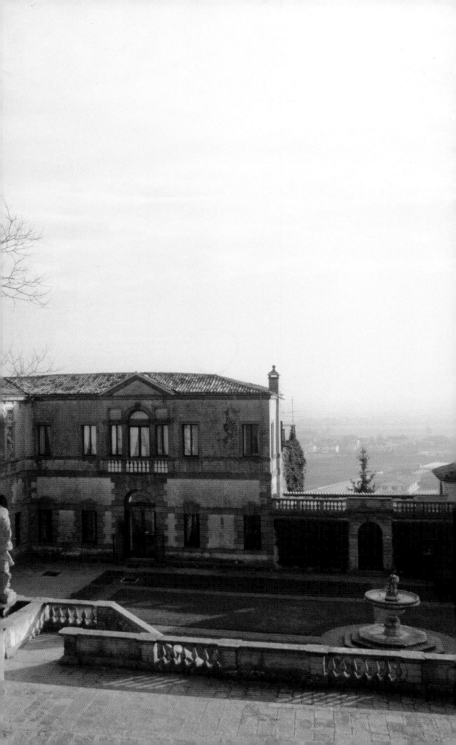

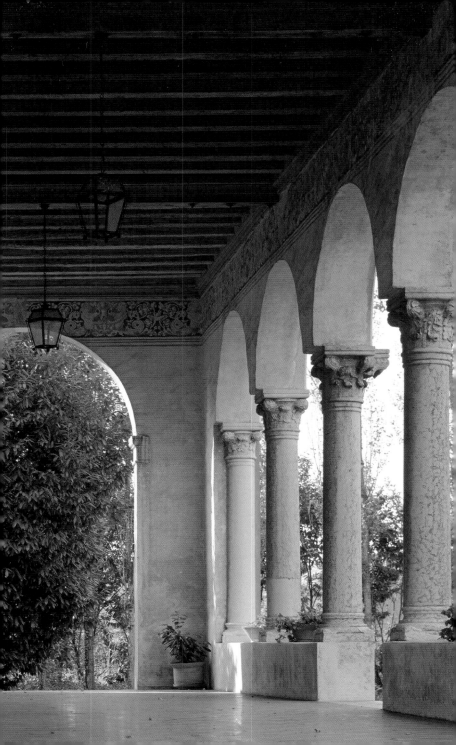

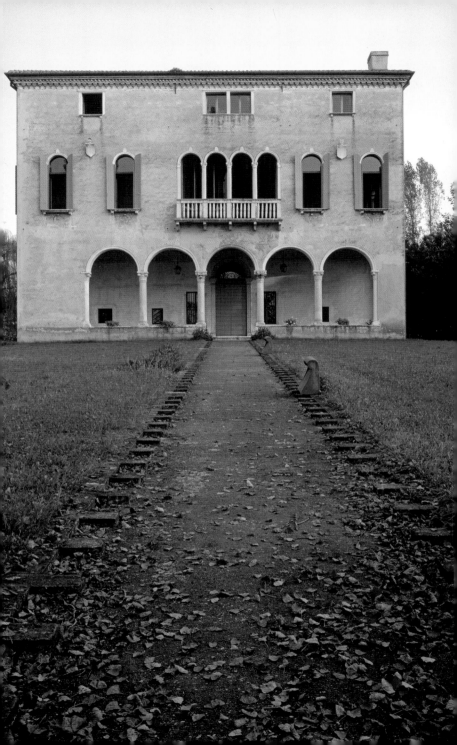

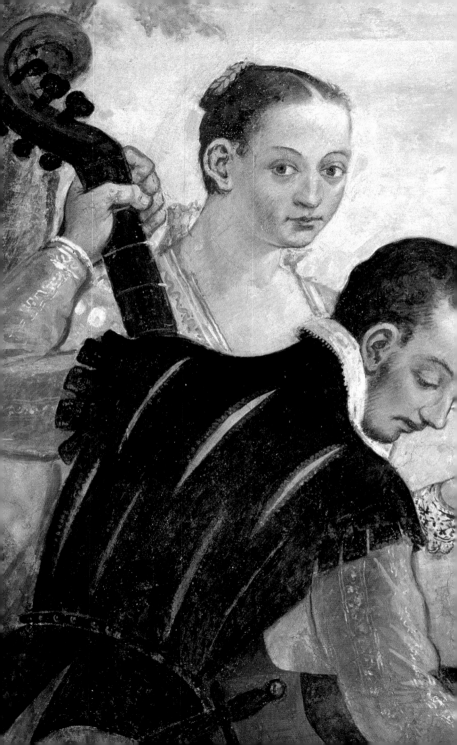

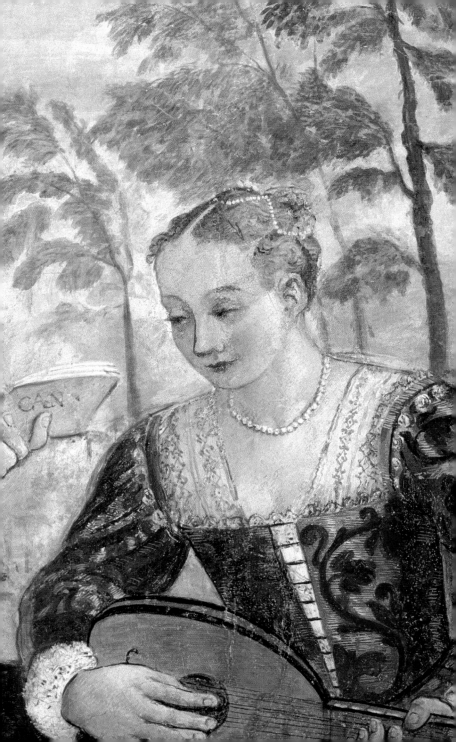

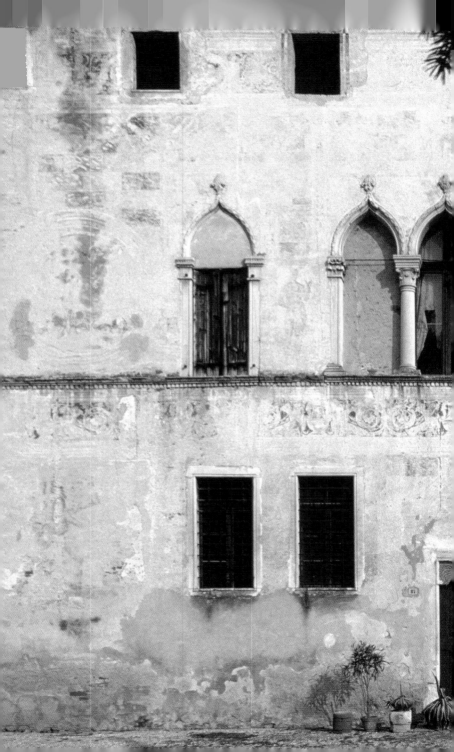

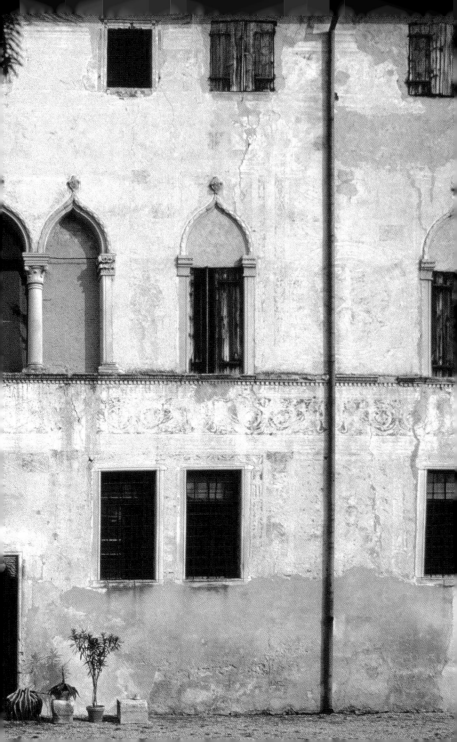

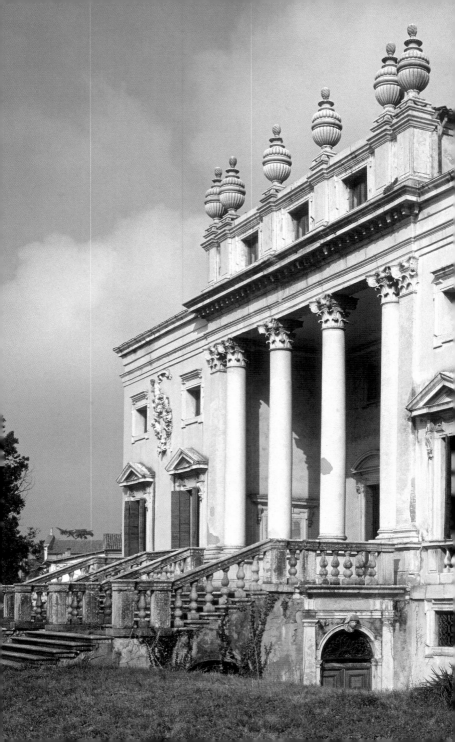

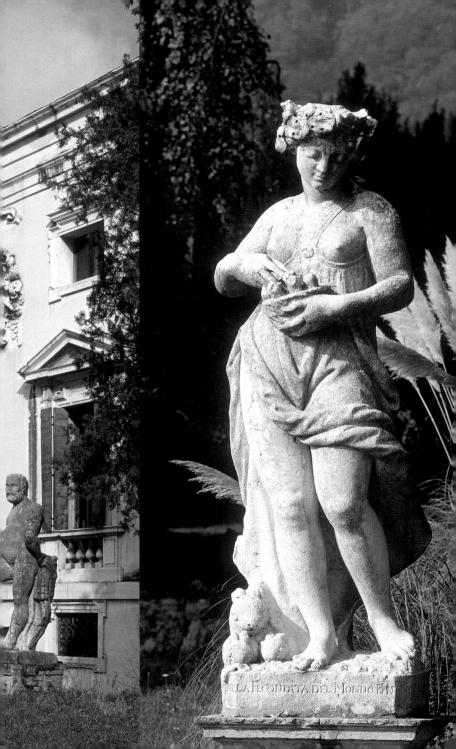

LA FECONDITA DEL MONDO E...

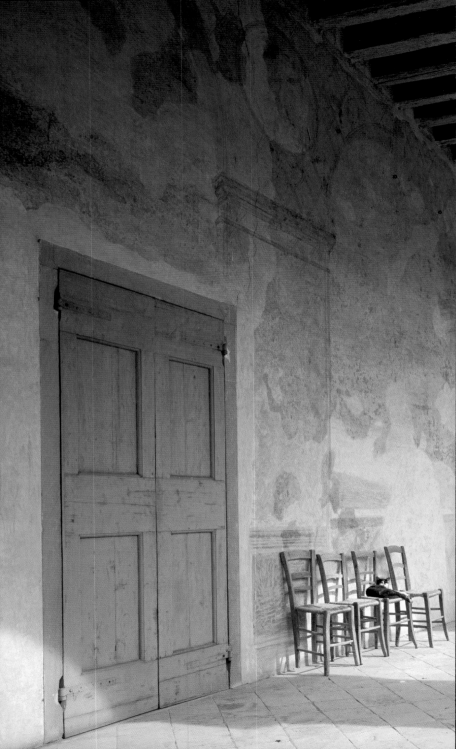

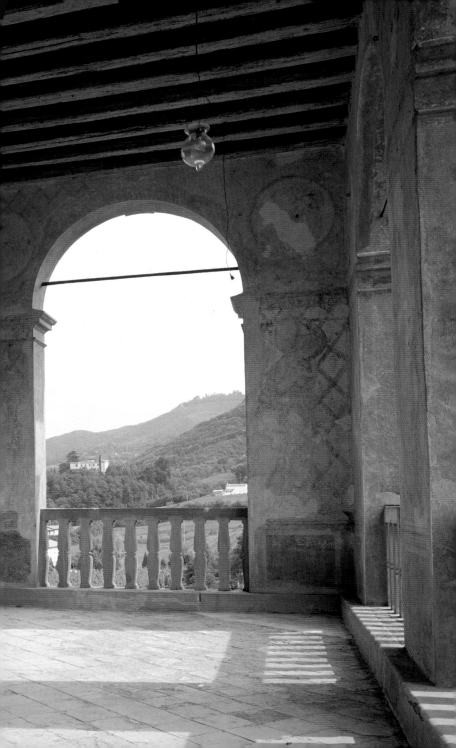

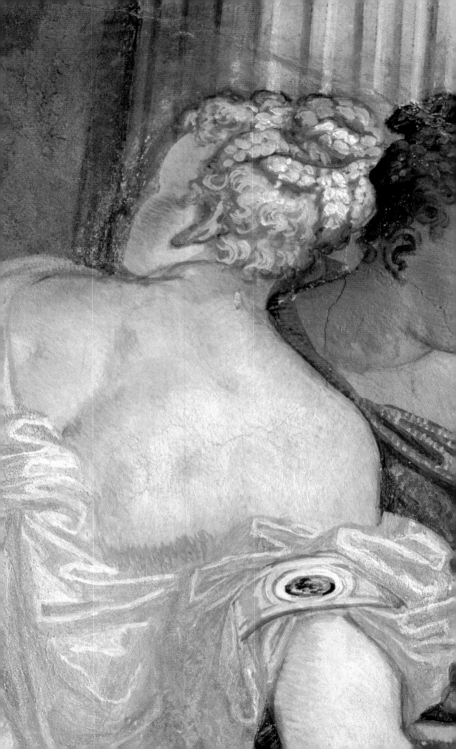

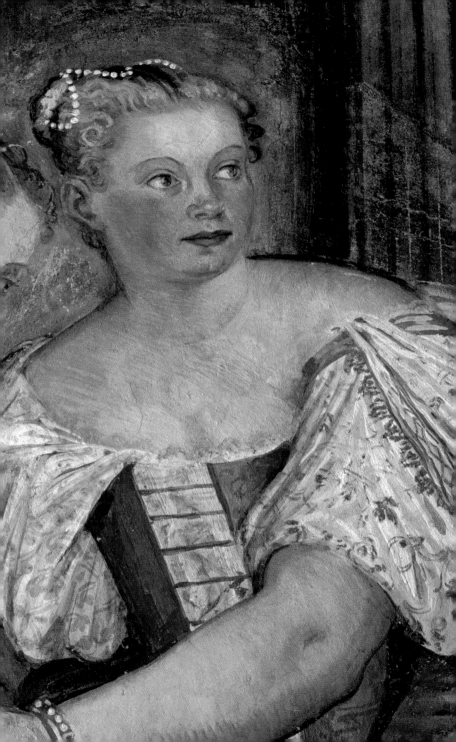

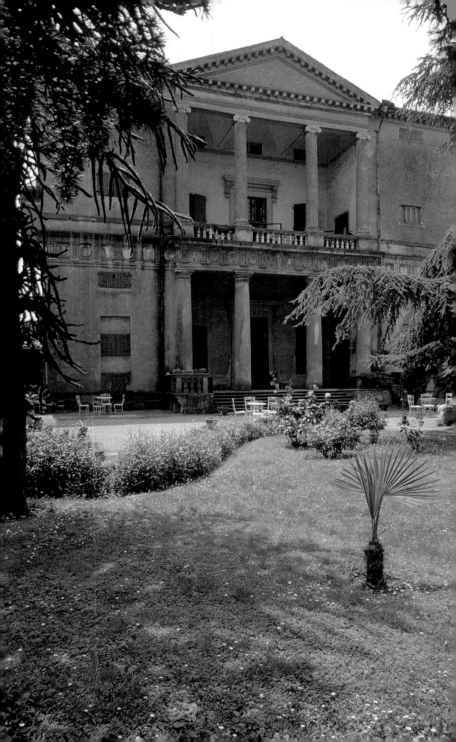

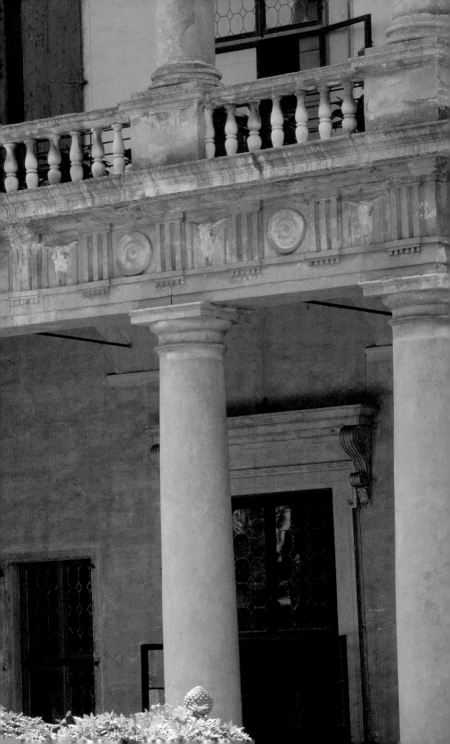

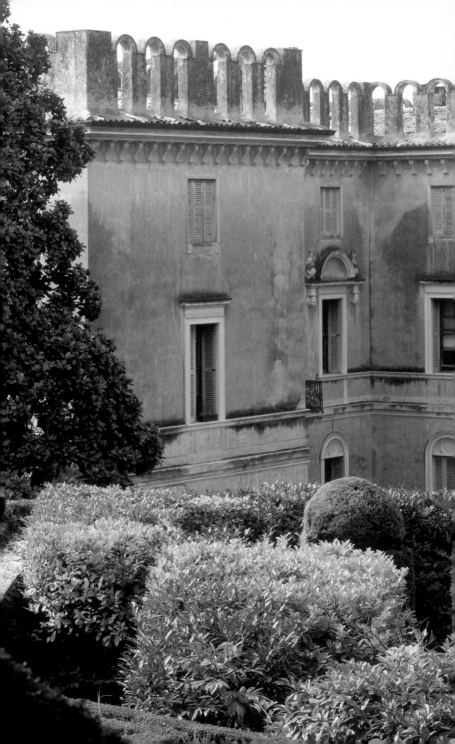

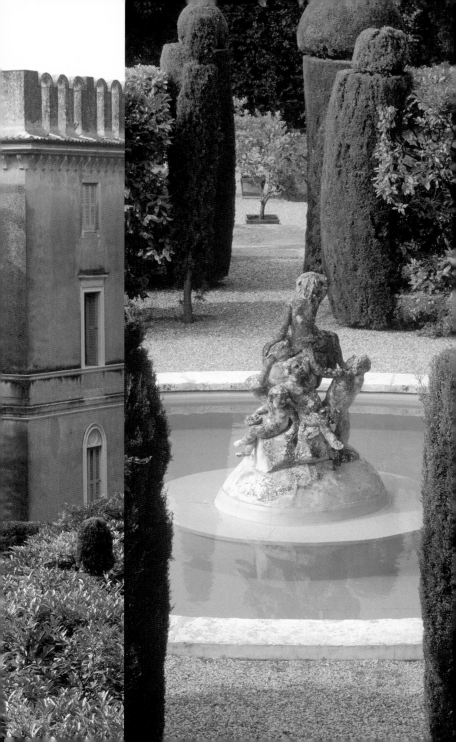

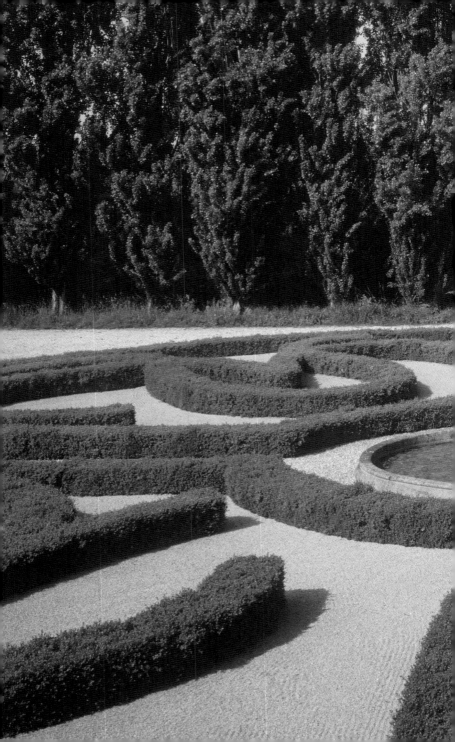

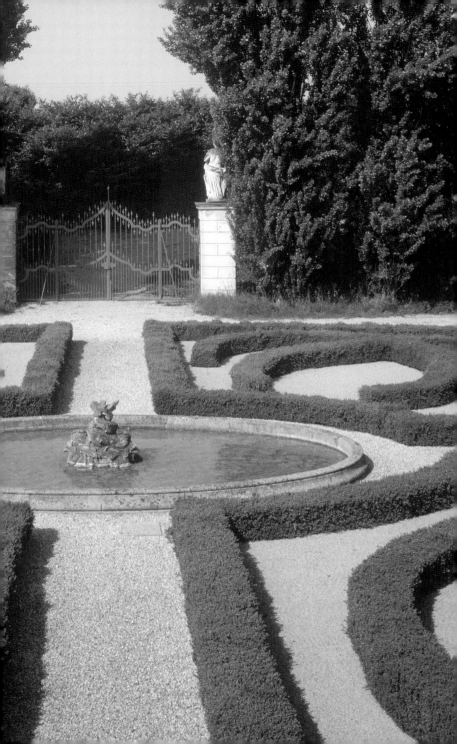

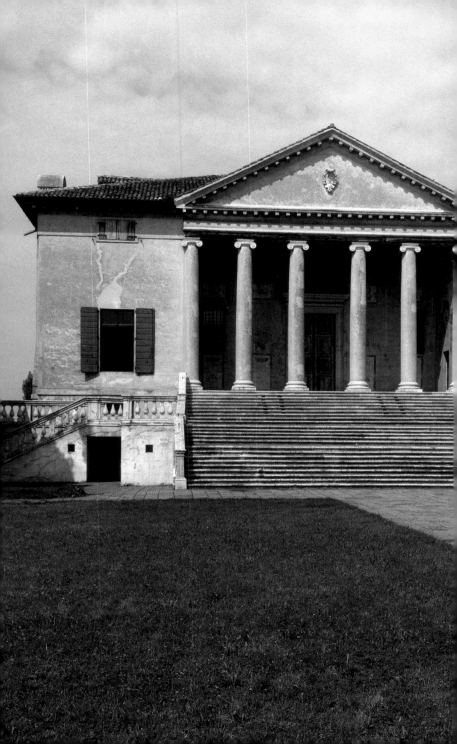

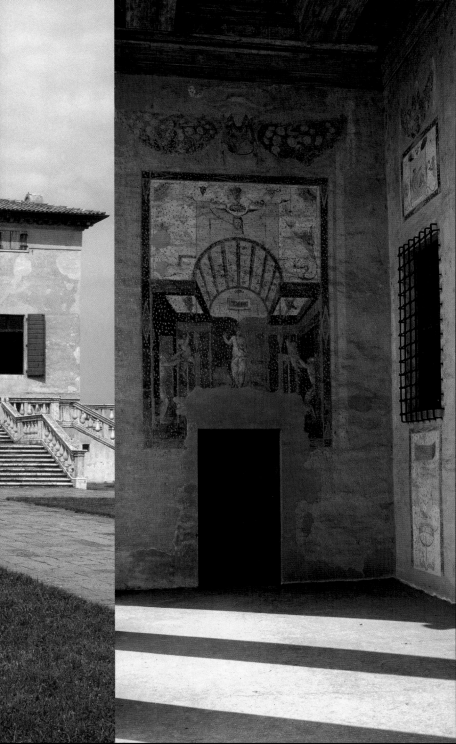

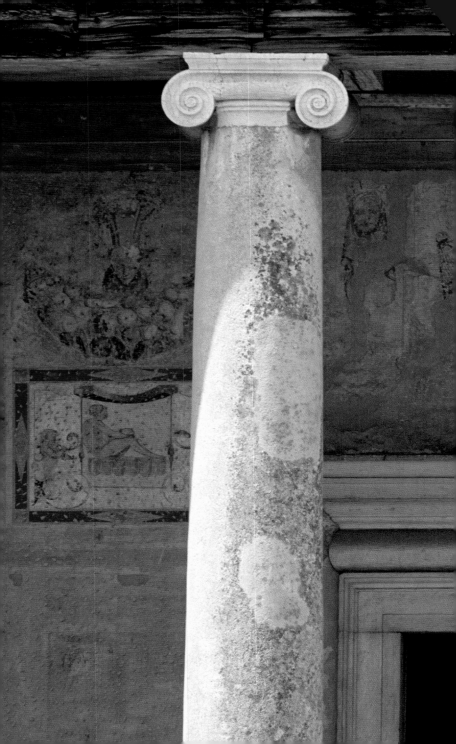

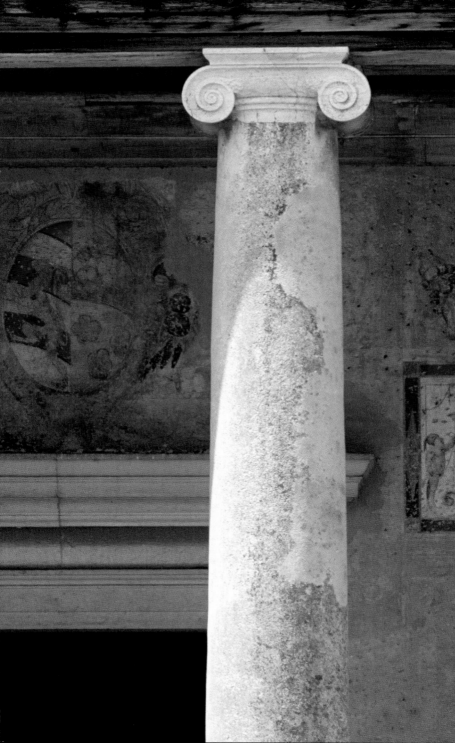

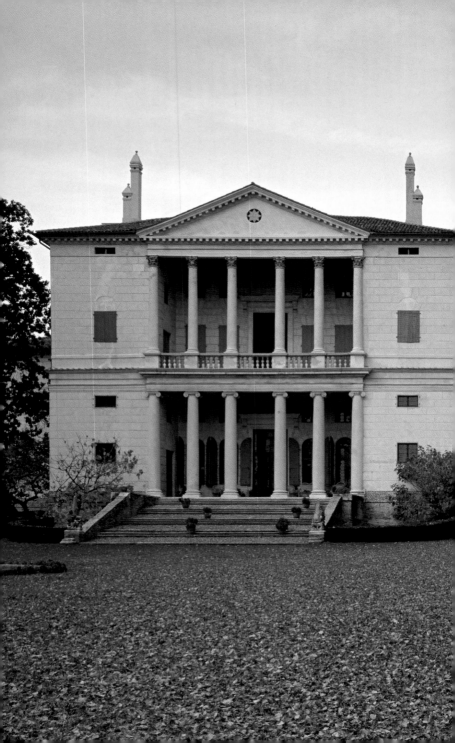

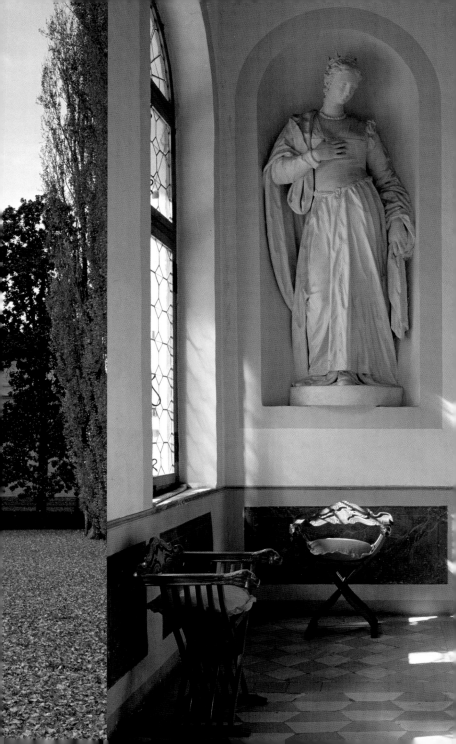

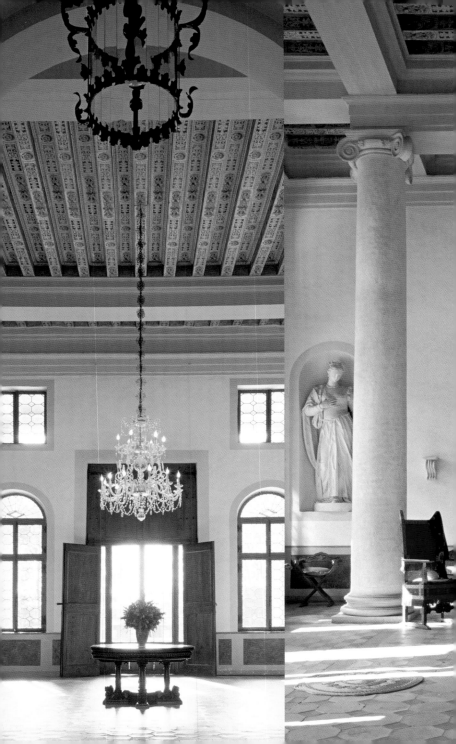

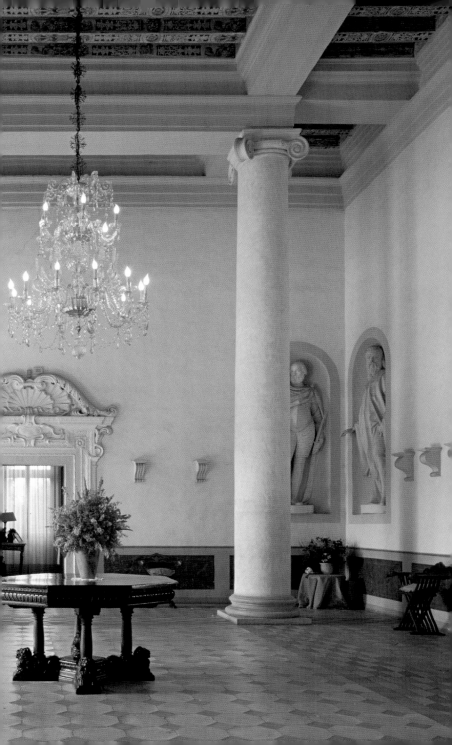

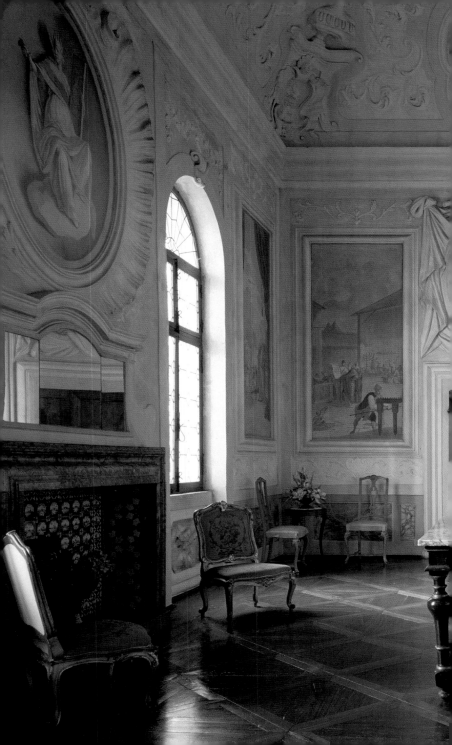

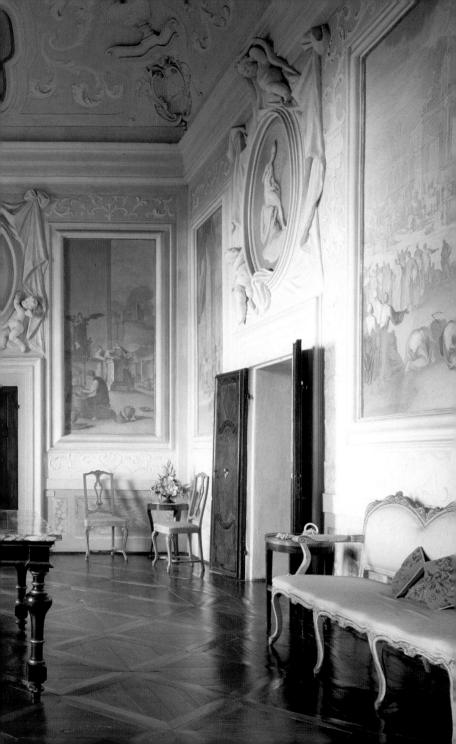

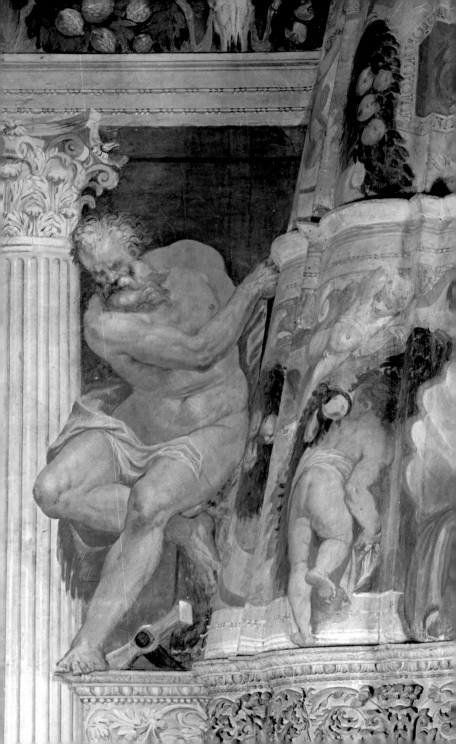

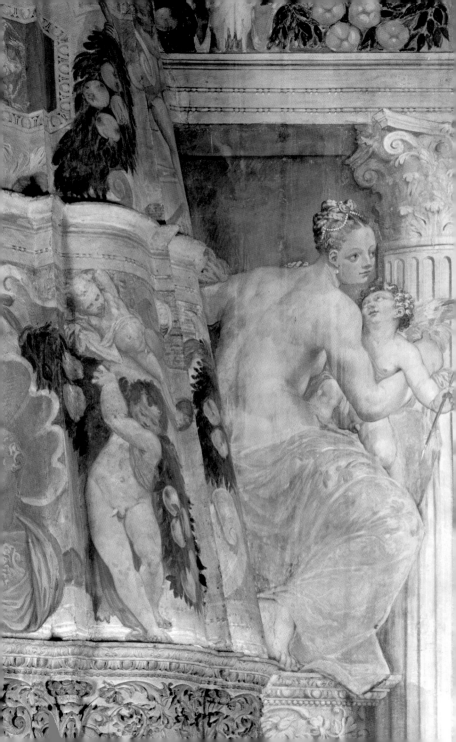

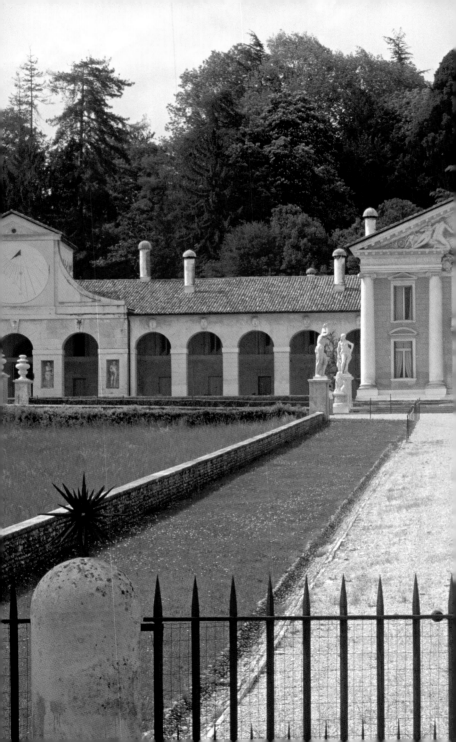

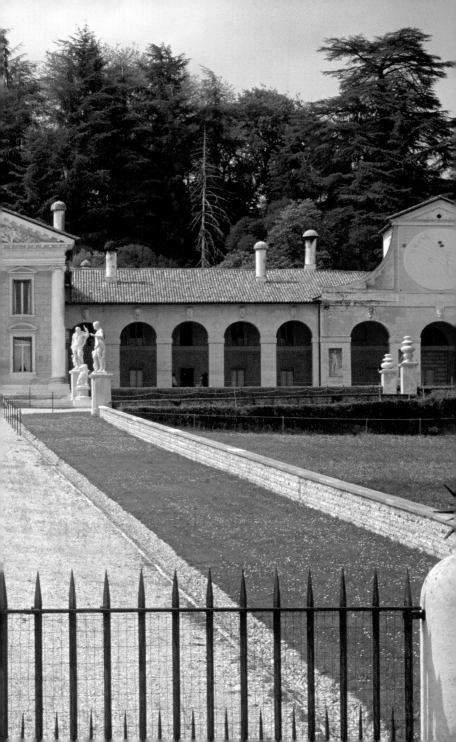

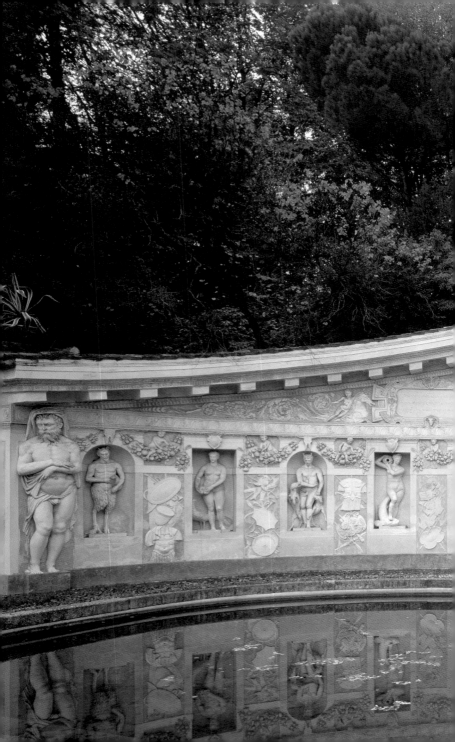

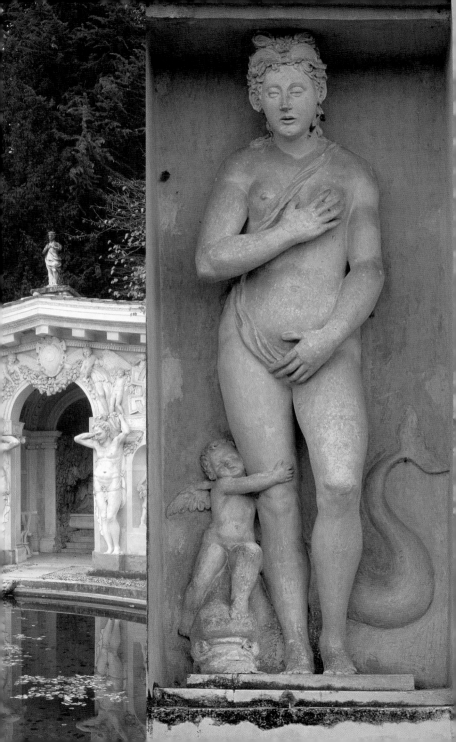

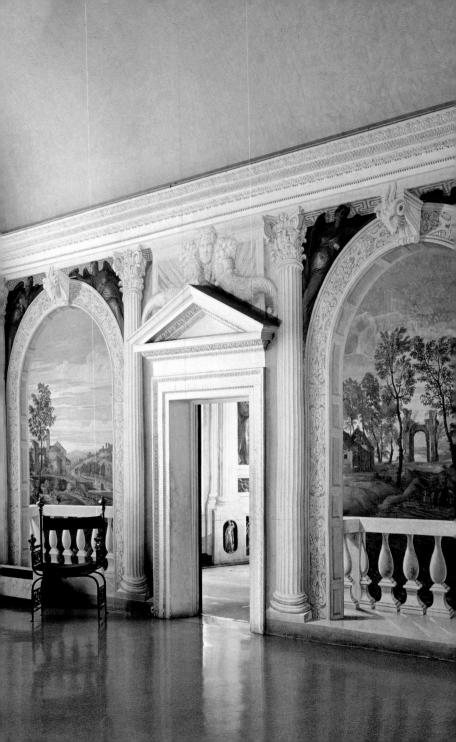

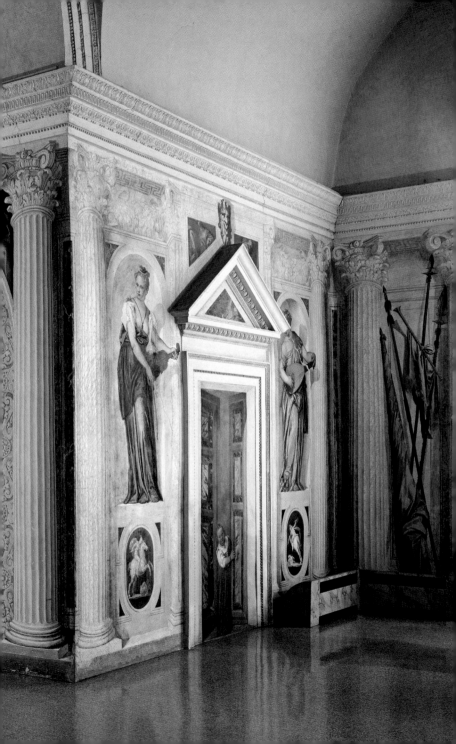

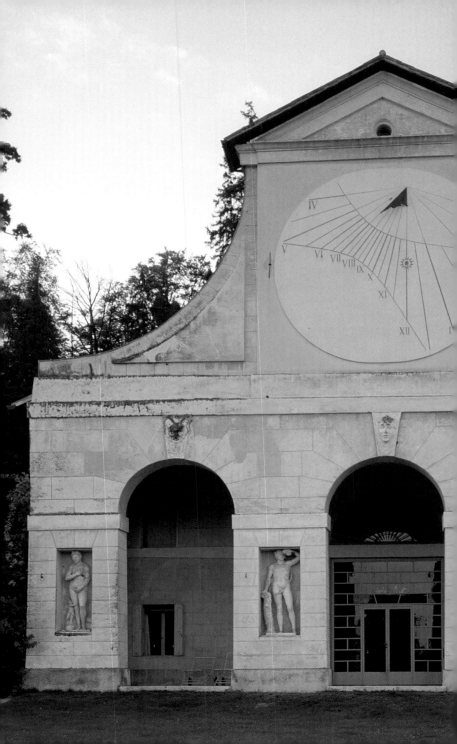

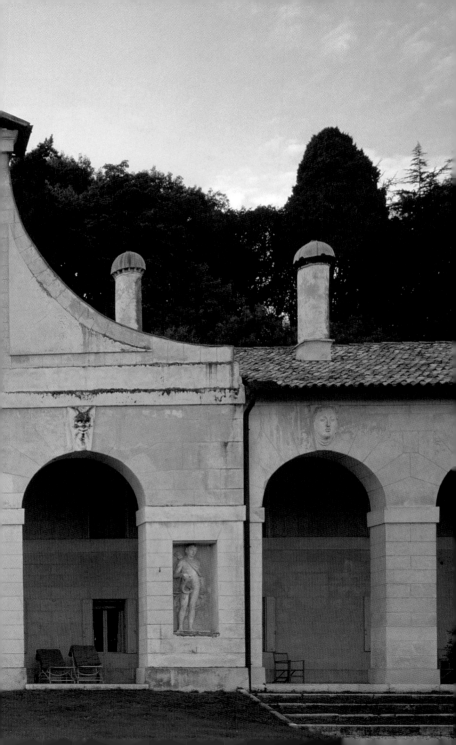

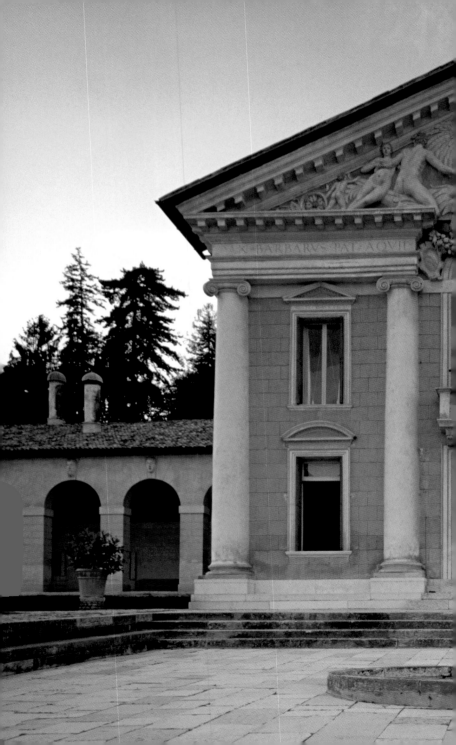

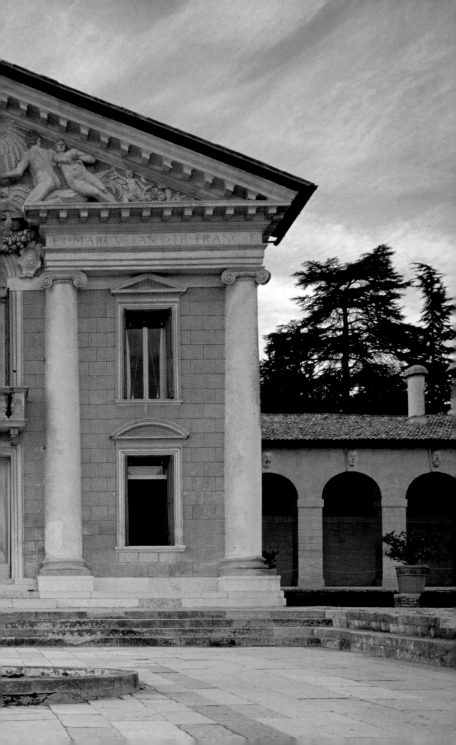

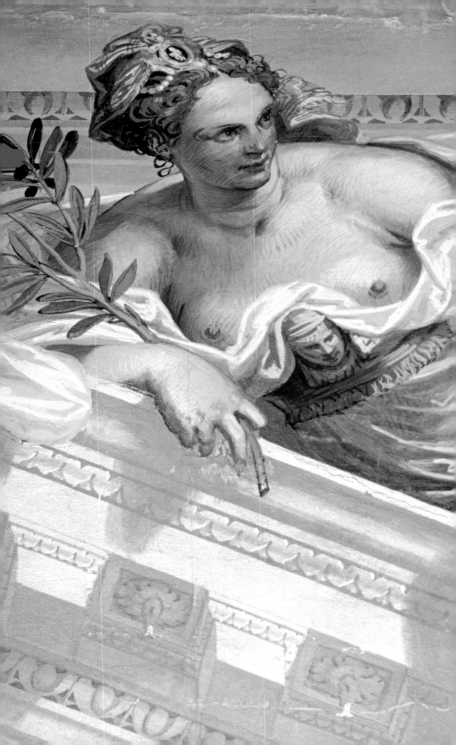

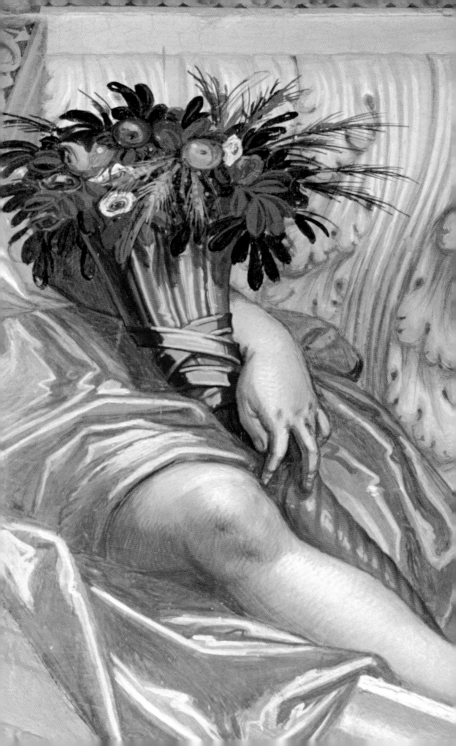

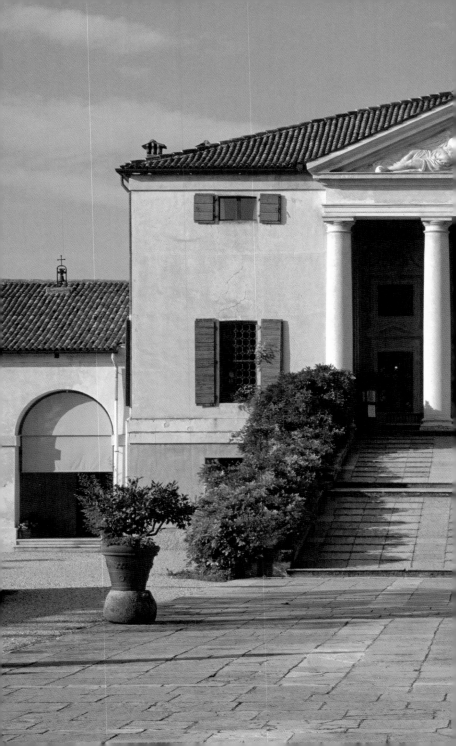

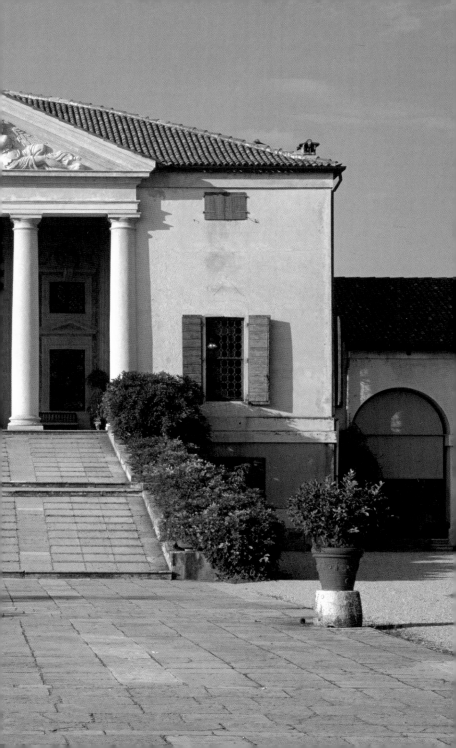

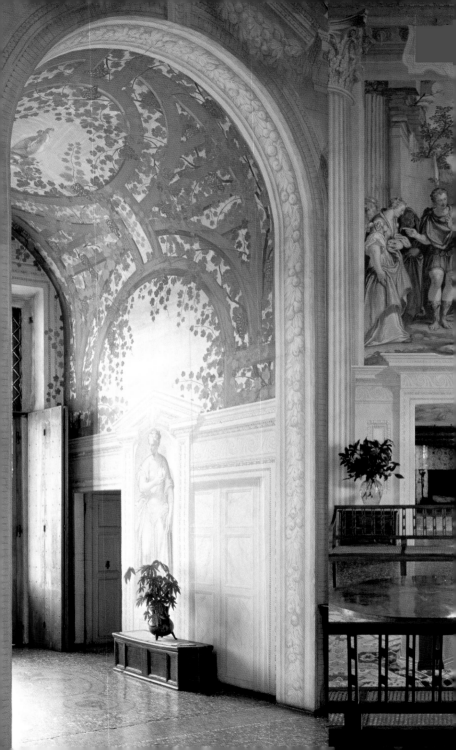

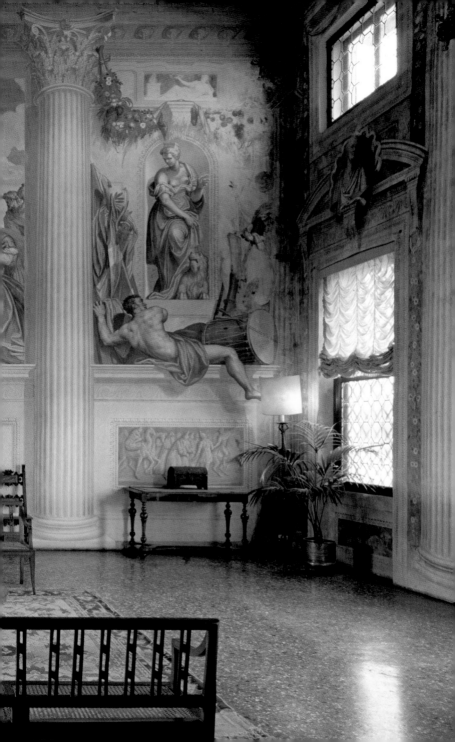

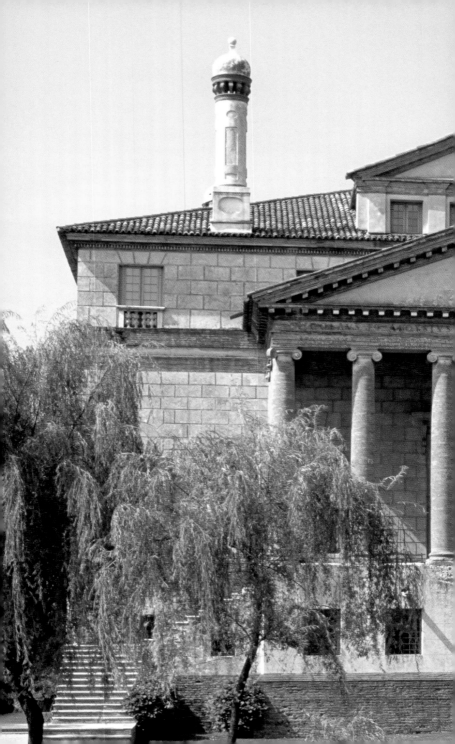

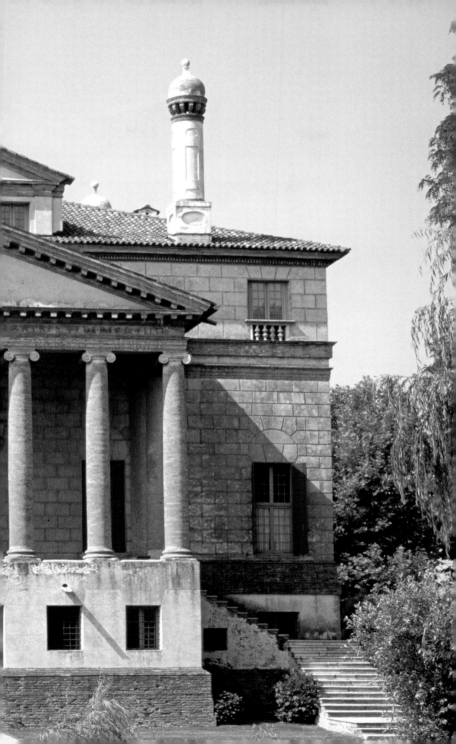

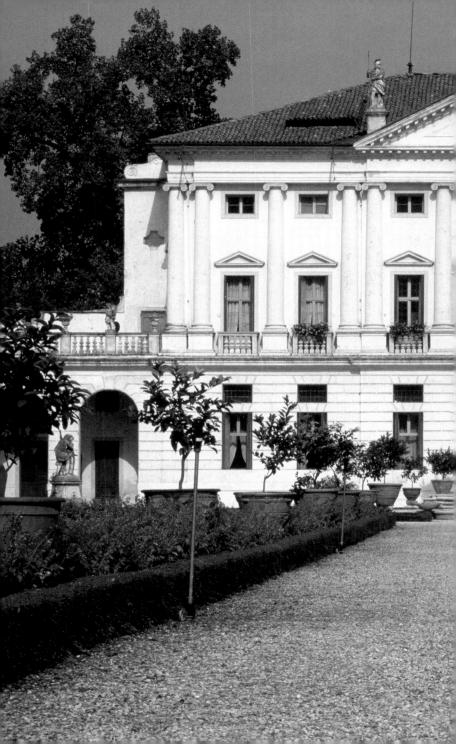

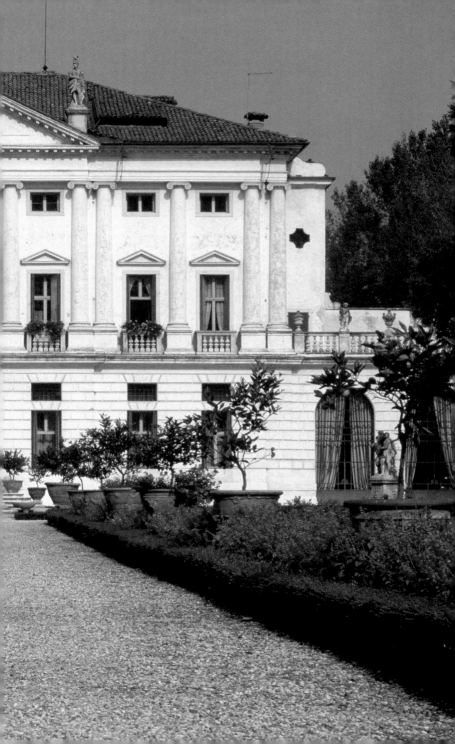

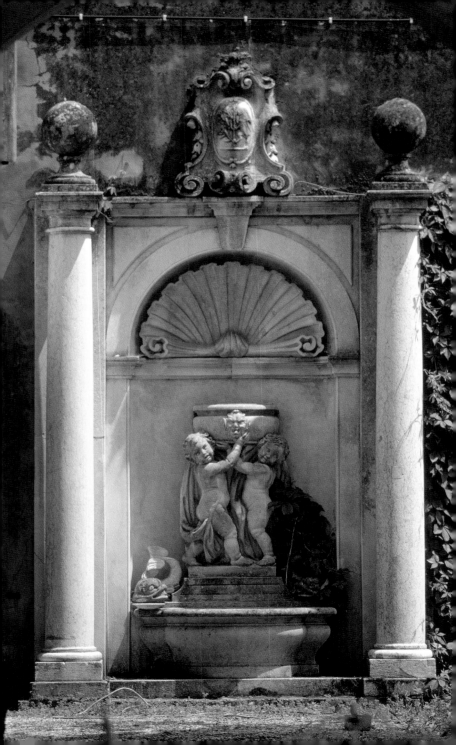

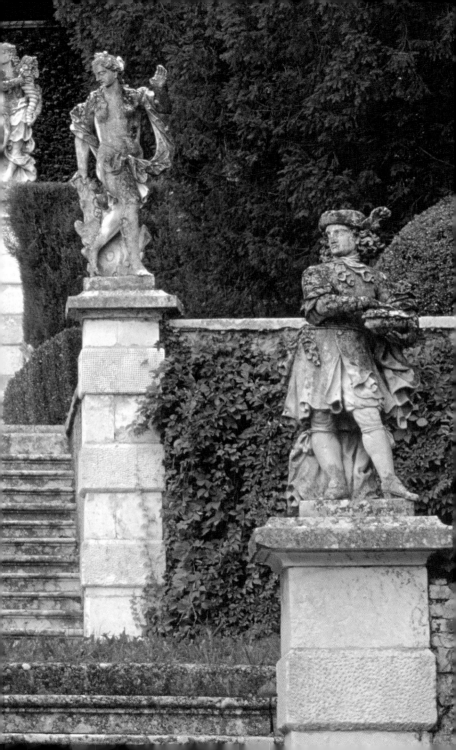

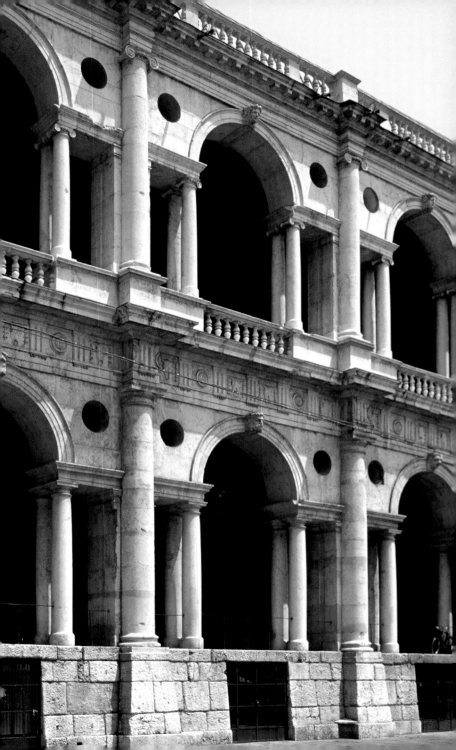

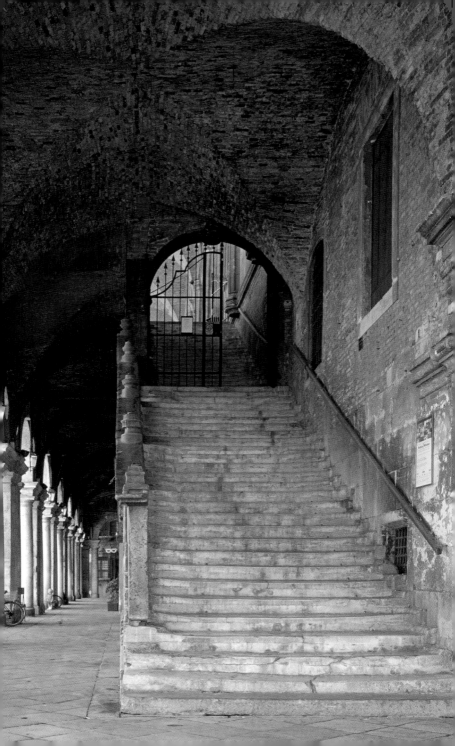

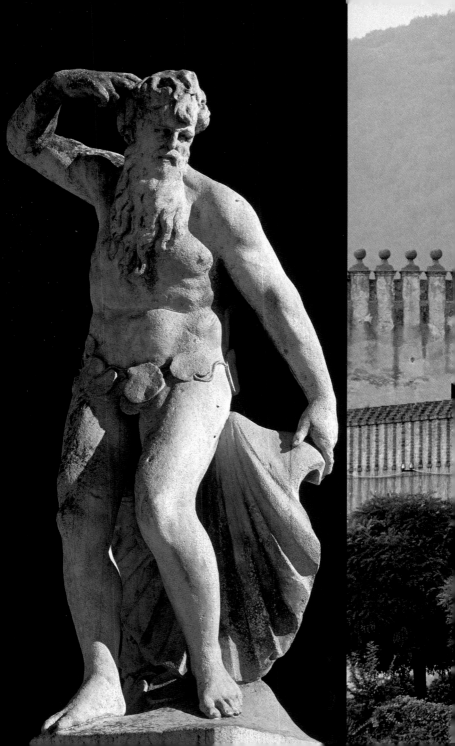

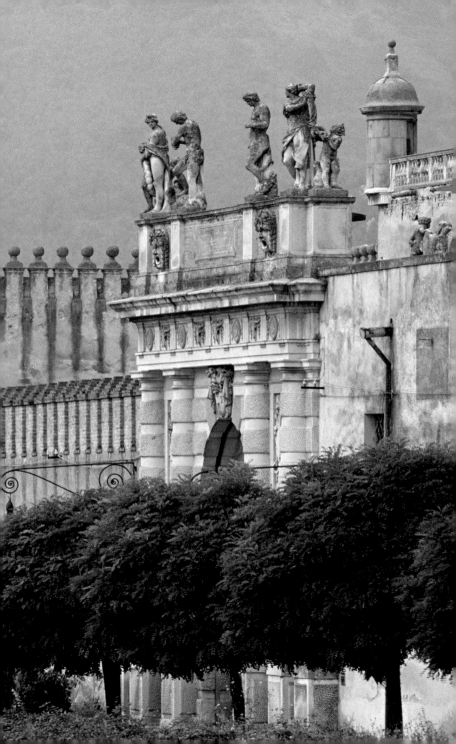

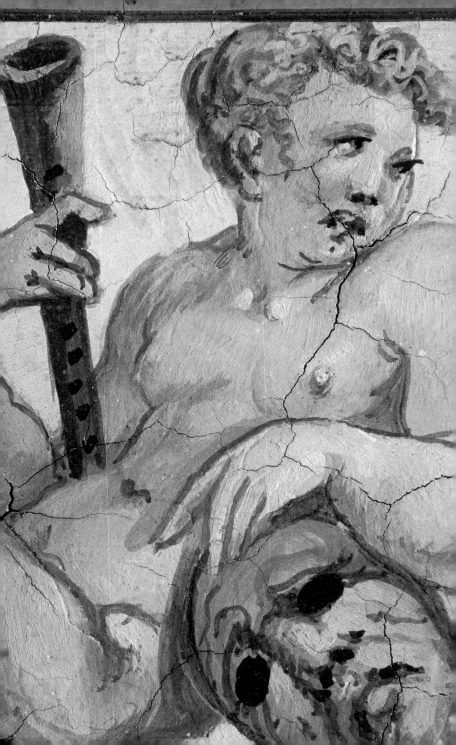

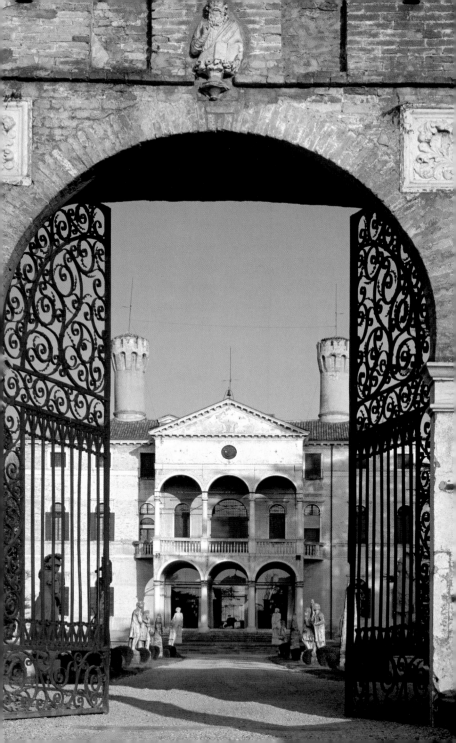

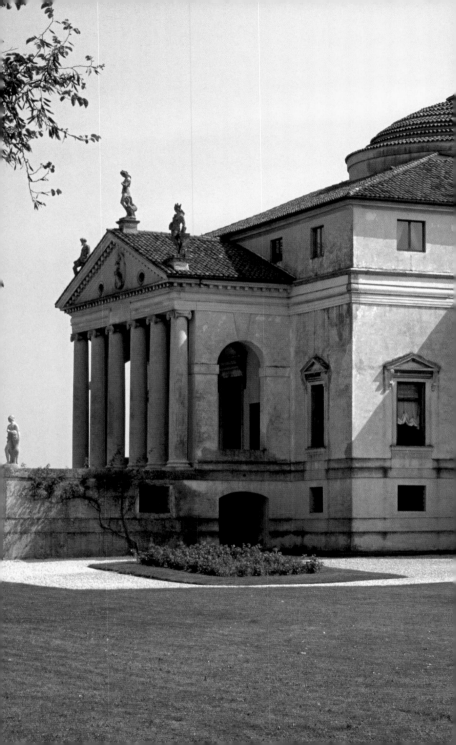

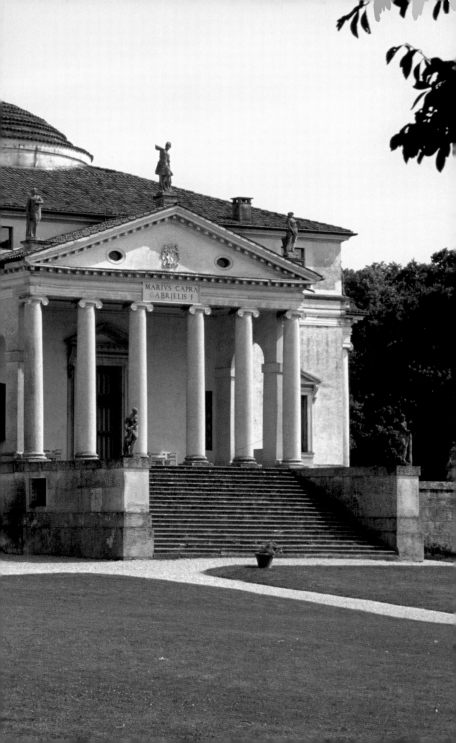

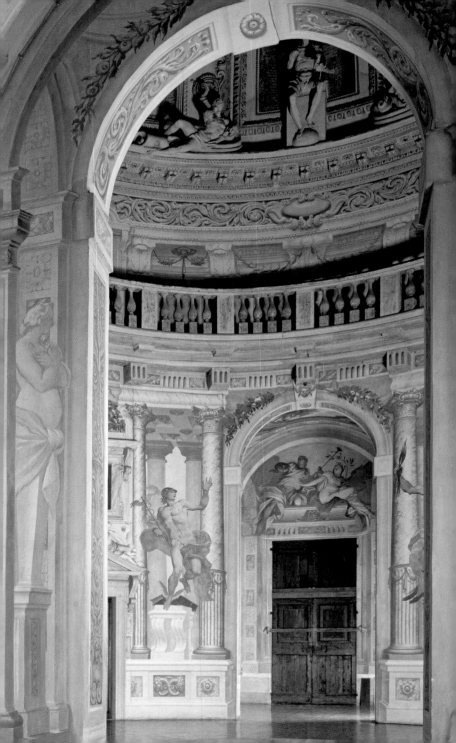

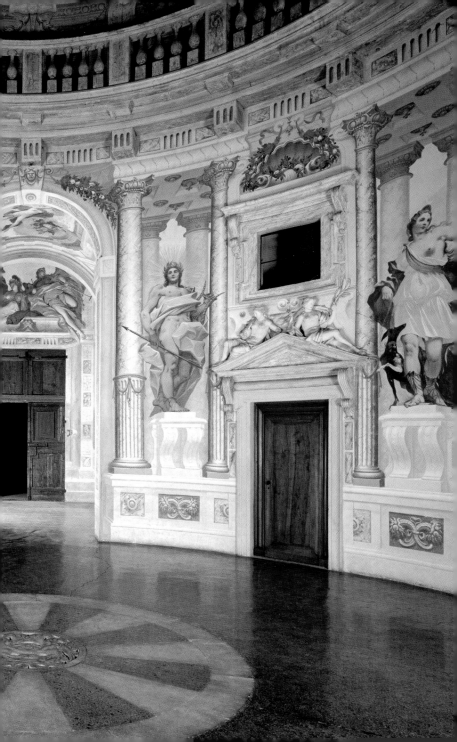

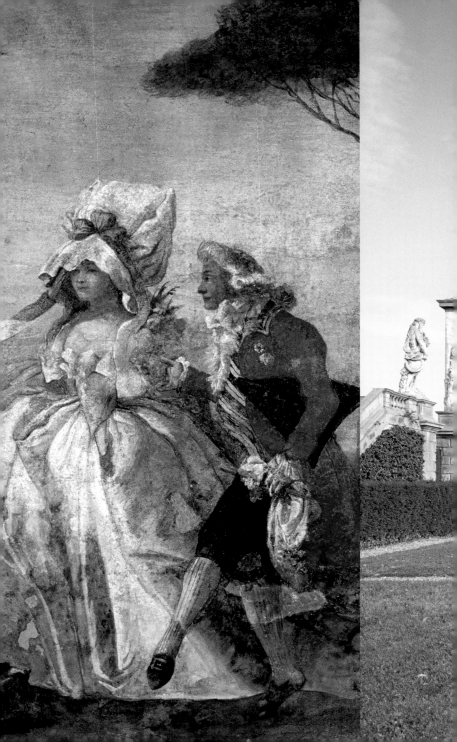

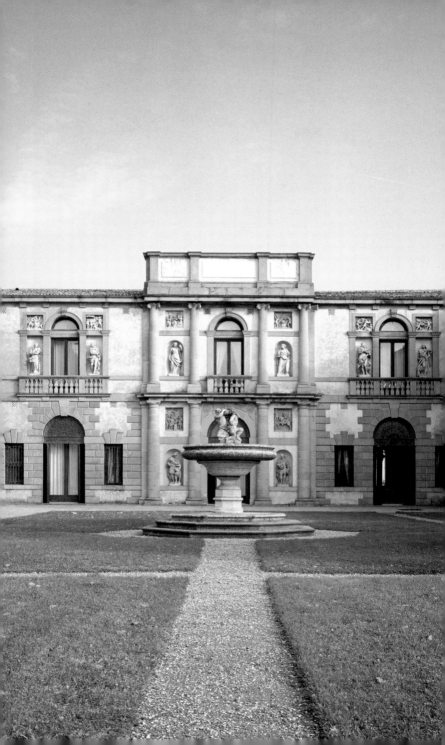

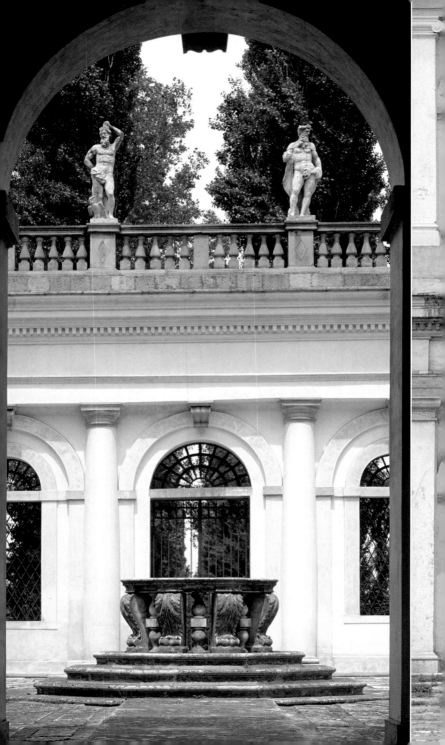

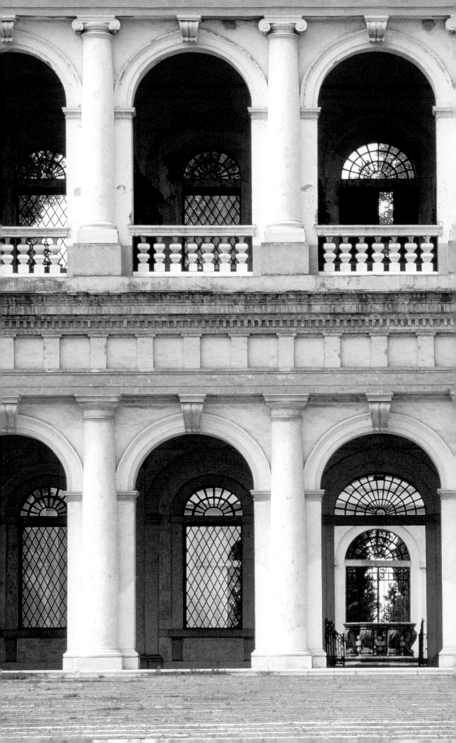

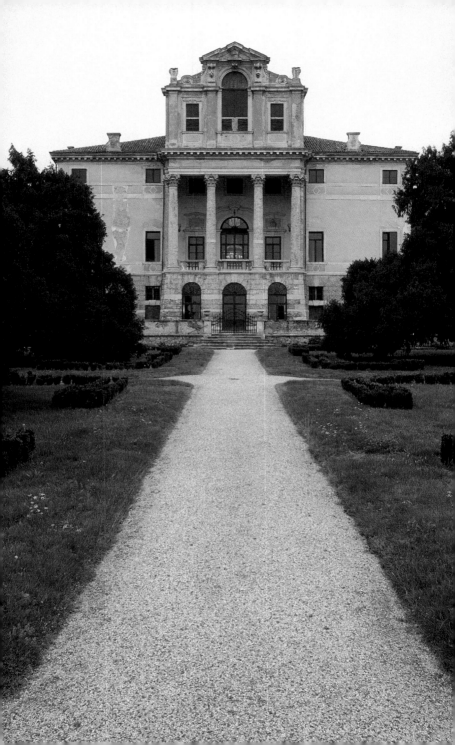

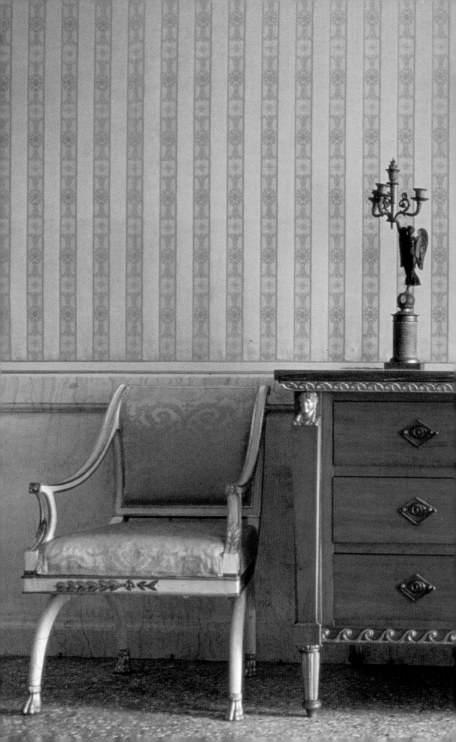

A Venetian Concert
28 x 28 cm
81 photos, 104 pgs.
4 Music CDs
ISBN 3-937406-21-2

Gefällt Ihnen dieses Buch?
Noch mehr Bilder und Musik genießen Sie
im earBOOKS Großformat.

If you liked this book,
you will enjoy the large format earBOOKS
with additional music and pictures.

Si vous avez aimez ce livre, vous l'apprécierez
dans sa version earBOOKS grand format,
avec encore plus de musiques et de photographies.

CD

Lorenzo Ghielmi: organ, harpsichord
Enrico Onofri: violin, voice
Margret Köll: harp

℗ 2003 winter & winter | With kind permission of winter & winter

PHOTO INDEX

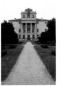

Villa Fracanzan Piovene (1710)
Francesco Muttoni
Orgiano, Vicenza
© Archivio Seat/Archivi Alinari

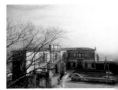

Villa Duodo annex (late 16th century)
including the St. George Chapel and a
staircase (18th century)
Vincenzo Scamozzi/Andrea Tirali,
Monselice, Padua
© Bildarchiv Monheim/Paolo Marton

Portico from the Villa Dall' Aglio (late 15th
century) Lughignano di Casale sul Sile, Treviso
© Bildarchiv Monheim/Paolo Marton
Villa Dall' Aglio
© Bildarchiv Monheim/Paolo Marton

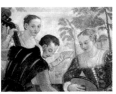

Fresco in the Villa Campiglia »The Concert«
(1560–70) by Giovanni Antonio Fasolo,
Albettone, Vicenza
© Bildarchiv Monheim/Paolo Marton

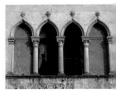

Facade element from the Villa Spessa
(15th century)
Carmignano di Brenta, Padua
© Bildarchiv Monheim/Paolo Marton

Villa Spessa (15th century)
Carmignano di Brenta, Padua
© Bildarchiv Monheim/Paolo Marton

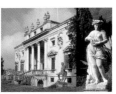

Villa Nani Mocenigo (1580–84)
Vincenzo Scamozzi, Canda, Rovigo
© Archivio Seat/Archivi Alinari
Statue in the Villa Barbarigo gardens,
Galzignano Terme, Padua
© Archivio Seat/Archivi Alinari

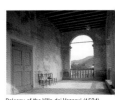

Balcony of the Villa dei Vescovi (1524)
Giangiorgio Trissino,
Luvigliano di Torreglia, Padua
© Bildarchiv Monheim/Paolo Marton

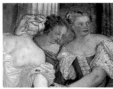

Fresco (detail) in the main hall of the
Villa Da Porto Colleoni by
Giambattista Zelotti/Giovanni Antonio Fasolo
Thiene, Vicenza
© Bildarchiv Monheim/Paolo Marton

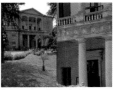

Garden facade, portico, loggia of the
Villa Pisani (ca. 1552–55) Andrea Palladio,
Montagnana, Padua
© Bildarchiv Monheim/Paolo Marton
Loggia of the Villa Pisani
© Bildarchiv Monheim/Paolo Marton

Villa Guerrieri Rizzardi (16th century) Bardoli
Veneto, © Copyright The Garden Picture Libr
John Ferro Sims • Garden on the grounds of
Villa Guerrieri Rizzardi (16th century), redesi
by Jappelli (1840) © Copyright The Garden
Picture Library/John Ferro Sims

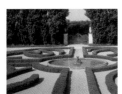

Formal parterre and pond on the grounds
of the Villa Emo, Capodilista, Veneto
© Copyright The Garden Picture Library/ John
Ferro Sims

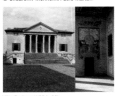

Villa Badoer (1554–63)
Andrea Palladio, Fratta Polesine, Rovigo
© Archivio Seat/Archivi Alinari
Fresco (circa 1544) by Giallo Fiorentino
in the portico of the Villa Badoer
© Archivio Seat/Archivi Alinari

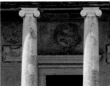

Ionic columns from the portico of the
Villa Badoer (1554–63) Andrea Palladio,
Fratta Polesine, Rovigo
© Bridgeman Art Library

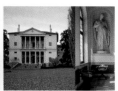
Back facade of the Villa Cornaro (1551–54)
Andrea Palladio, Piombino Dese, Padua
© Bildarchiv Monheim/Paolo Marton
Statue by Camillo Mariani in the hall of
four columns in the Villa Cornaro
© Artur/Klaus Frahm

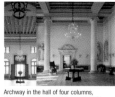
Archway in the hall of four columns,
Villa Cornaro (1551–54) Andrea Palladio,
Piombino Dese, Padua, © Artur/Klaus Frahm
The hall of four columns in the Villa Cornaro
© Artur/Klaus Frahm

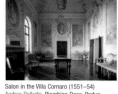
Salon in the Villa Cornaro (1551–54)
Andrea Palladio, Piombino Dese, Padua
© Artur/Klaus Frahm

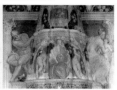
Hearth with fresco (1555) by
Giovanni Antonio Fasolo in the Villa Da Porto
Colleoni, Thiene, Vicenza
© Bildarchiv Monheim/Paolo Marton

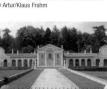
Villa Barbaro (ca. 1561) Andrea Palladio,
Maser, Treviso
© Bildarchiv Monheim/Paolo Marton

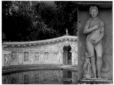
Garden architecture on the grounds of the
Villa Barbaro (ca. 1561) Andrea Palladio,
Maser, Treviso
© Bildarchiv Monheim/Paolo Marton
Nymph sculpture in the garden of the Villa
Barbaro, © Artur/Klaus Frahm

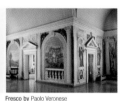
Fresco by Paolo Veronese
in the crociera of the Villa Barbaro
© akg-images / Erich Lessing

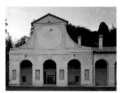
Dovecote of the Villa Barbaro (ca. 1561)
Andrea Palladio, Maser, Treviso
© Artur/Klaus Frahm

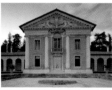
Central block of the Villa Barbaro
© Artur/Klaus Frahm

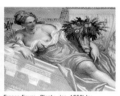
Fresco figure »Plenty« (ca. 1558) by
Giambattista Zelotti
in the Villa Emo (1555–65)

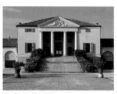
Villa Emo (1555–65)
Andrea Palladio, Fanzolo di Vedelago, Treviso
© Artur/Klaus Frahm

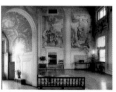
Archway in the Villa Emo (1555–65)
Andrea Palladio, Fanzolo di Vedelago, Treviso
© Artur/Klaus Frahm
Fresco (ca. 1558) in the main hall of the Villa
Emo by Giambattista Zelotti
© Bildarchiv Monheim/Paolo Marton

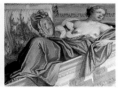
Fresco figure »Wisdom« (ca. 1558) by
Giambattista Zelotti in the Villa Emo (1555–65)
Andrea Palladio, Fanzolo di Vedelago, Treviso
© Bildarchiv Monheim/Paolo Marton

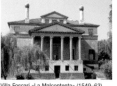
Villa Foscari »La Malcontenta« (1549–63)
Andrea Palladio, Mira, Veneto
© Bildarchiv Monheim/Paolo Marton

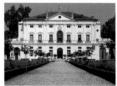
Villa Marcello (18th century)
Levada di Piombino Dese, Padua
© Bridgeman Art Library

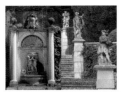

Fountain by Giorgio Massari in the courtyard of
the Villa Negri Lattes (1715), Istrana, Treviso
© Bildarchiv Monheim/Paolo Marton
Garden statues at the Villa Garzadori Da Schio
by Orazio Marinali, Costozza di Longare, Vicenza
© Bildarchiv Monheim/Paolo Marton

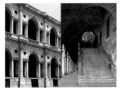

Palazzo della Ragione (Basilica Palladiana)
(1561–17) Andrea Palladio, Vicenza
© Bildarchiv Monheim/Schütze/Rodemann
Palazzo della Ragione © Achim Bednorz

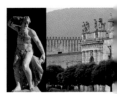

Neptune statue (1658) by Girolamo Albanese
on the stairs of the Villa Poiana,
Poiana Maggiore, Vicenza
© Archivio Seat/Archivi Alinari
Villa del Cataio (1570) Pio Enea degli Obizzi,
Battaglia, Veneto © Bridgeman Art Library

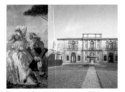

Detail of a fresco (1564) by Pierfrancesco Giallo
in the salon of the Villa Grimani-Molin Avezzo,
Fratta Polesine, Rovigo, © Archivio Seat/Archivi
Alinari • Villa Giustinian (early 16th century)
Andrea Palladio, Roncade, Treviso
© Bildarchiv Monheim/Paolo Marton

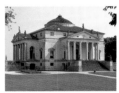

Villa Almerico Capra,
genannt »La Rotonda« (1566–70)
Andrea Palladio, Vicenza
© Schütze/Rodemann

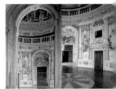

Archway in »La Rotonda«
© Bildarchiv Monheim/Paolo Marton
The main hall in »La Rotonda« (1566–70)
Andrea Palladio with frescos by Ludovico Dri
© Bildarchiv Monheim/Paolo Marton

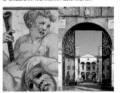

Fresco »A Country Minuett« (ca. 1778)
by Giandomenico Tiepolo in the Villa Tiepolo,
Zianigo di Mirano, Venezia
© Bildarchiv Monheim/Paolo Marton
Garden view of the Villa Duodo (16th and 17th
century) Vicenzo Scamozzi/Andrea Tiralis,
Monselice, Padua
© Bildarchiv Monheim/Paolo Marton

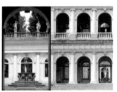

View from the collonade in the Villa Garzoni
(ca. 1540) Jacopo Sansovino,
Pontecasale di Candiana, Padua
© Bildarchiv Monheim/Paolo Marton
Arcade in the Villa Garzoni
© Bildarchiv Monheim/Paolo Marton

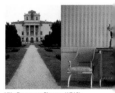

Villa Fracanzan Piovene (1710)
Francesco Muttoni, Orgiano, Vicenza
© Archivio Seat/Archivi Alinari
Napoleon's Bedroom in the Villa Pisani,
»La Nazionale«, Stra, Venezia
© Bridgeman Art Library